How to Draw Book for K
How to Draw 101 Cute Things for Kids Ages 6+

Thank you for choosing our drawing book! Before we get started, if you want some free activities (yes FREE), shoot us a message here:

Support@kidsactivitybooks.org

HOW TO USE THIS DRAWING BOOK:

1. Make sure to use a pencil and have an eraser ready.

2. The first step is given for you to draw on. Draw the black lines that you see from the next steps.

3. Continue to add the black lines from each additional step.

4. If you can't get past a step, feel free to trace the final picture and then try drawing it over from the beginning.

5. You will be completing your drawing on step 1 of each page, so relax and have fun!!

Proudly Designed and Printed in the USA

Feel free to email us for questions & customer service at

Support@kidsactivitybooks.org

DRAWING THEMES
Cute Animals

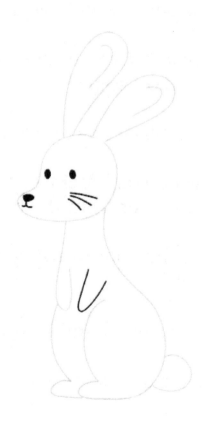

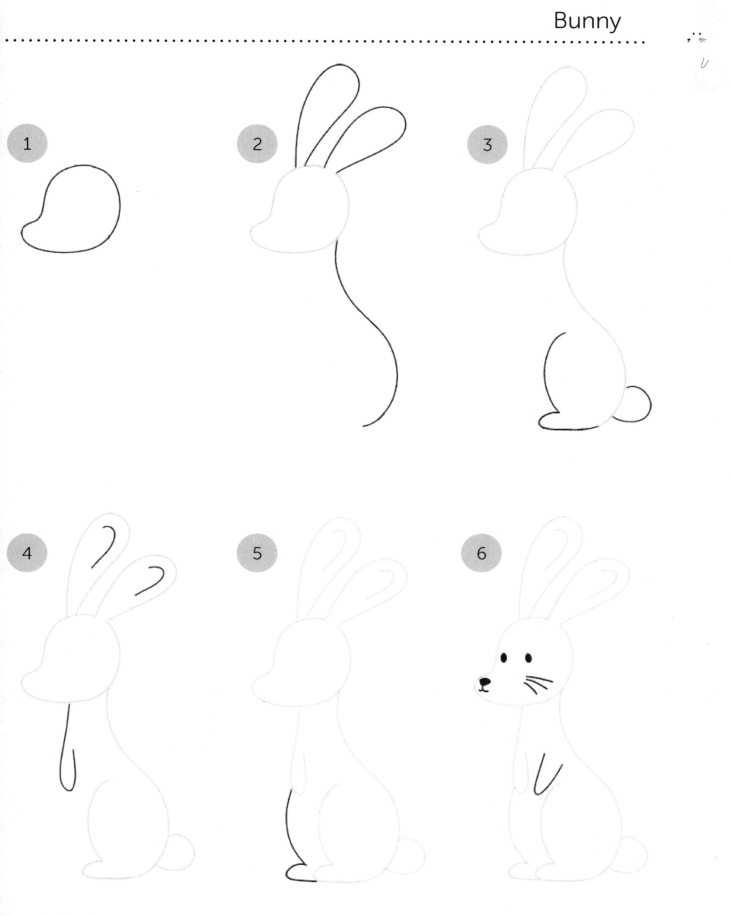

Chameleon

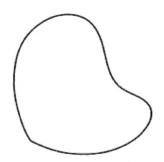

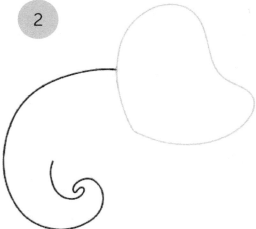

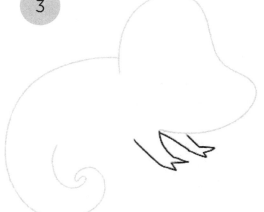

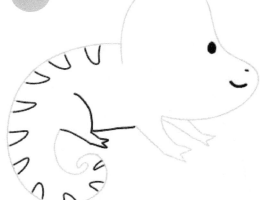

 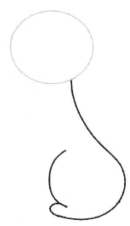

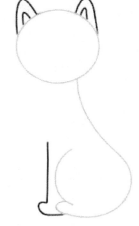

 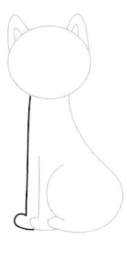

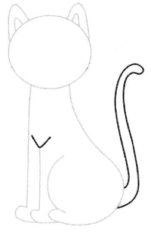

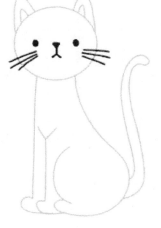


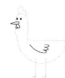

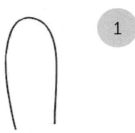

1

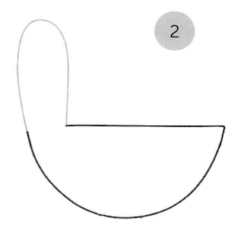

2

3

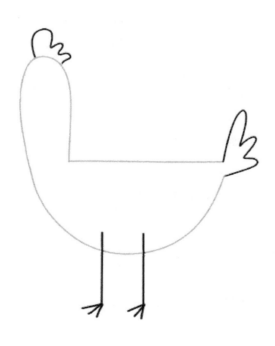

4

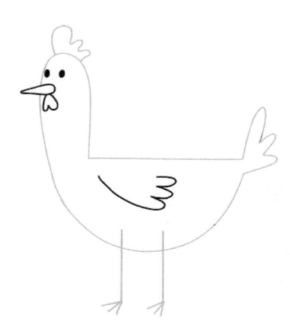

6

1

2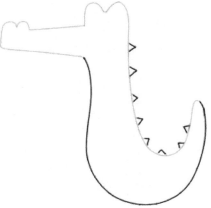

3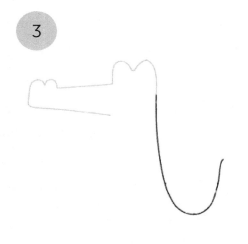

4

5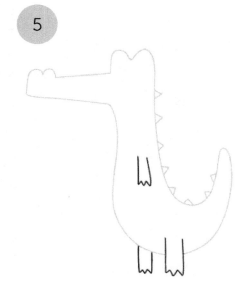

6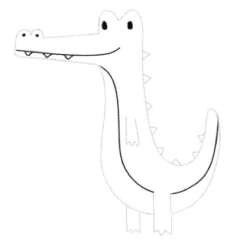

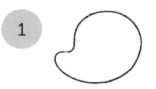

Deer

1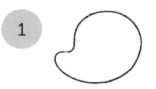

2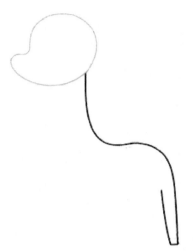

3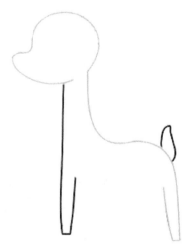

4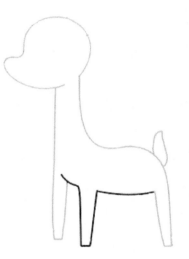

5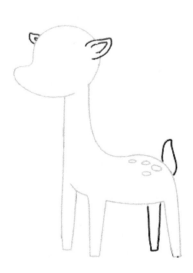

6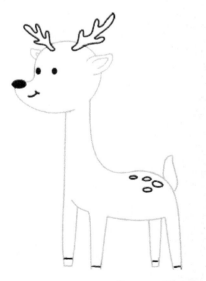

Cute Animal

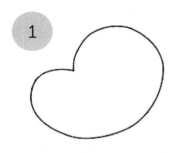

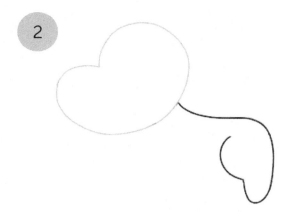

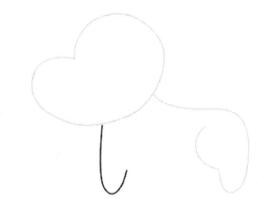

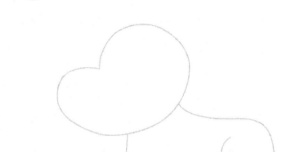

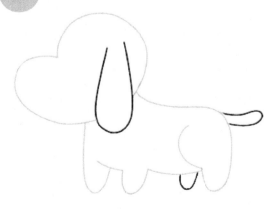

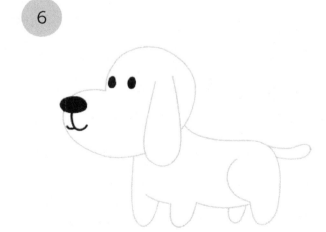

Elephant

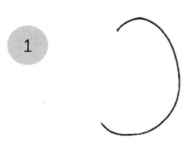

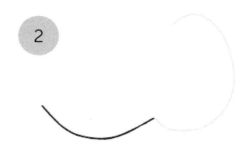

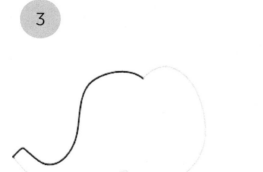

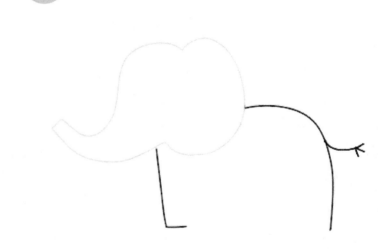

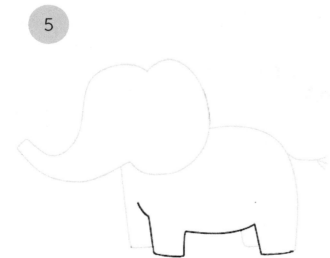

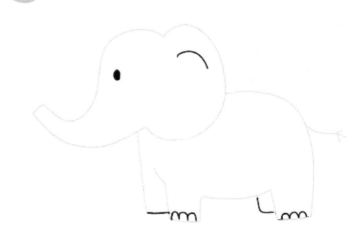

Cute Animals

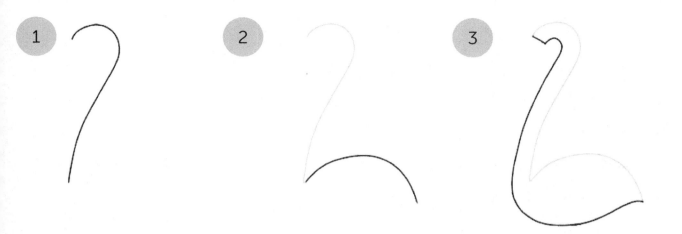

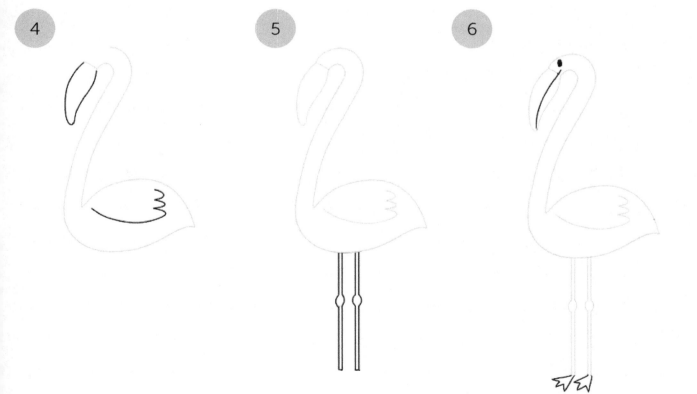

Fox

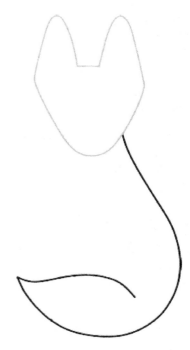

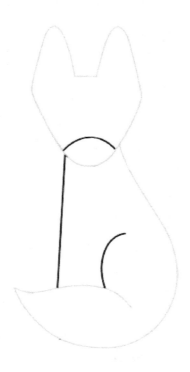
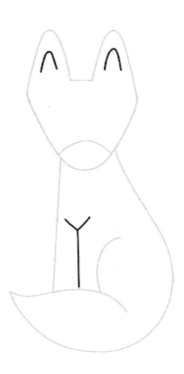
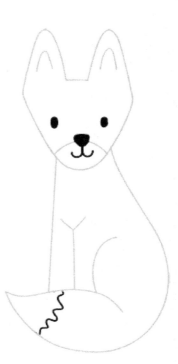

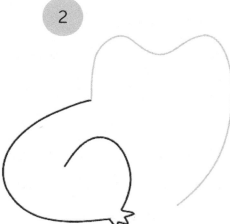

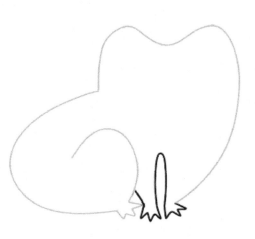

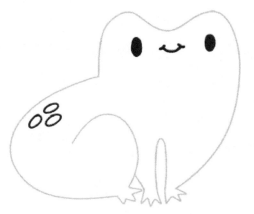

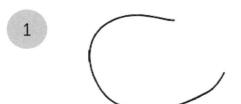

1

2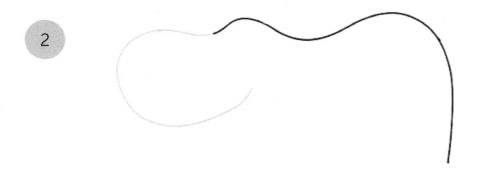

3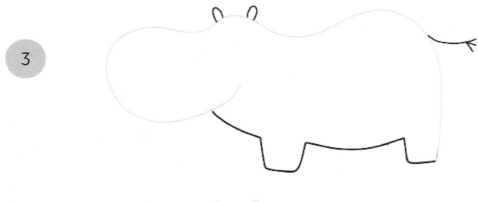

4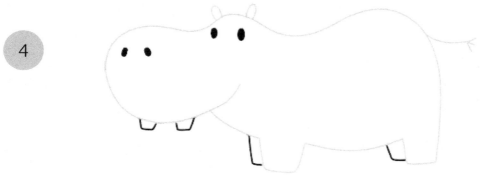

14

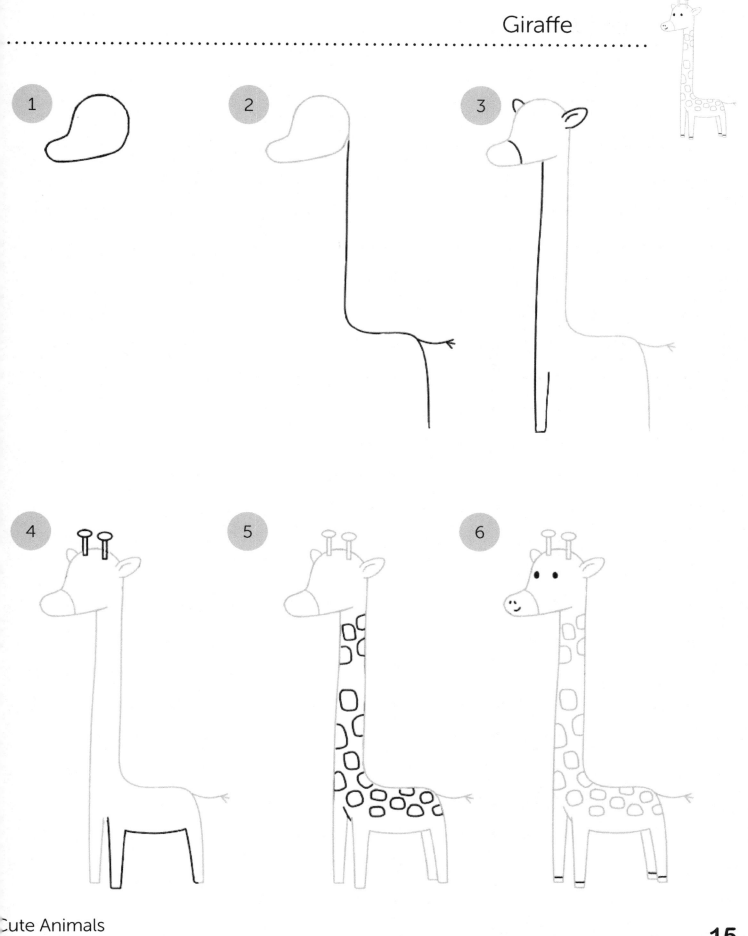

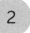

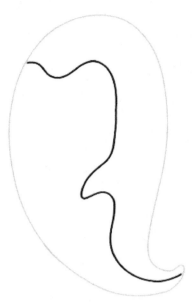

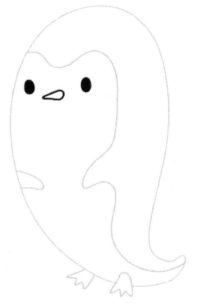

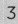

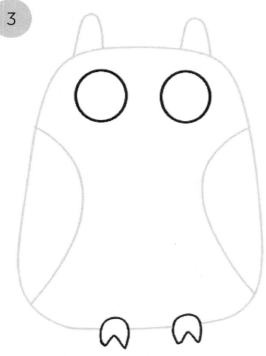

Cute Animals

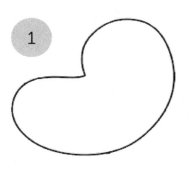

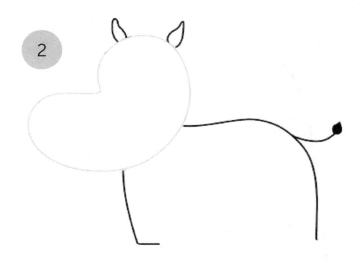

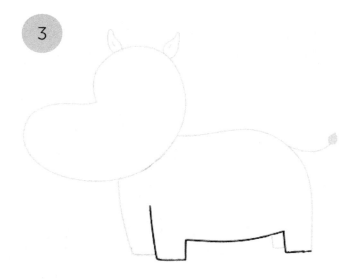

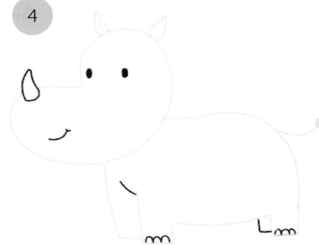

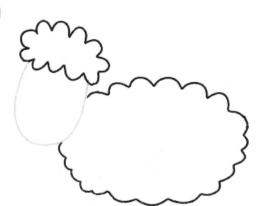

1

2

3
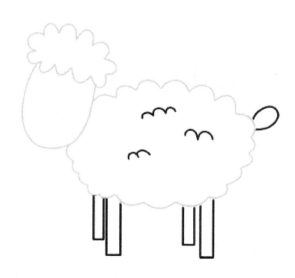

4
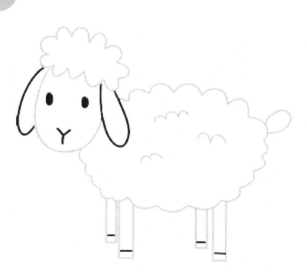

1

2

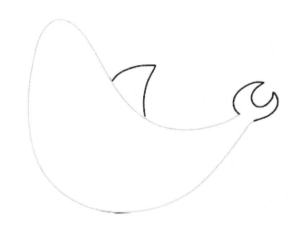

3

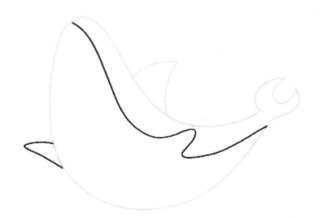

4

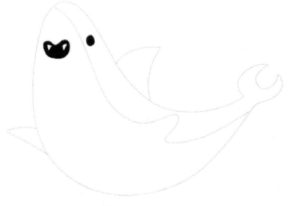

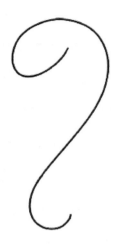

1

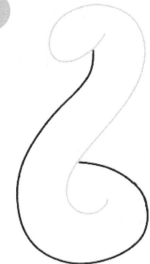

2

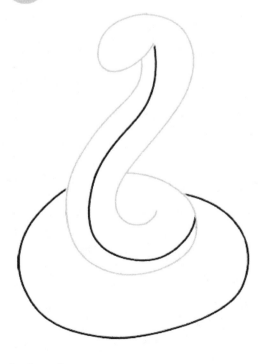

3

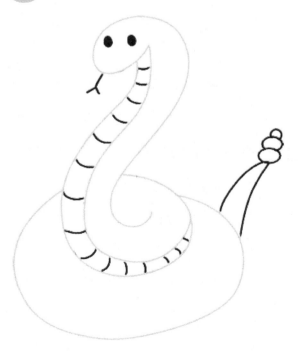

4

Toucan

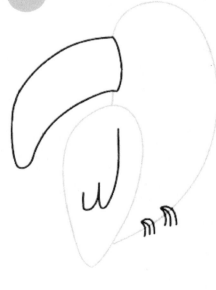

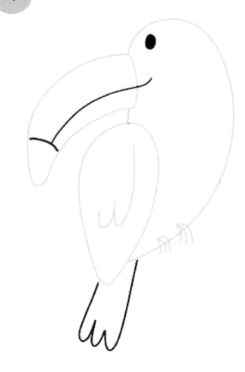

1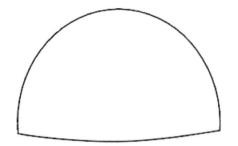

2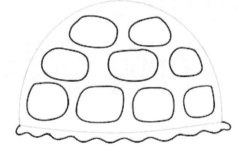

3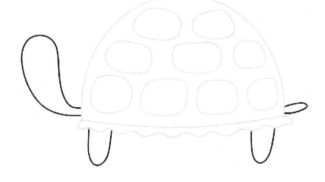

4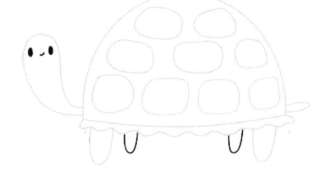

DRAWING THEMES
Happy Foods

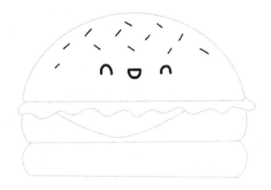

1

2

3

4

5

6

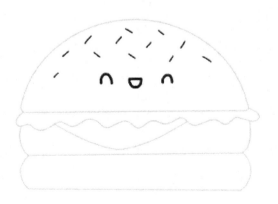

1

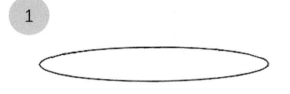

2

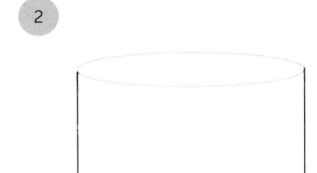

3

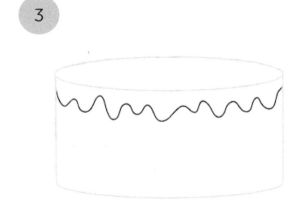

4

5

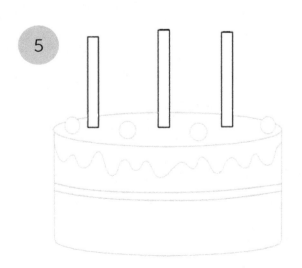

6

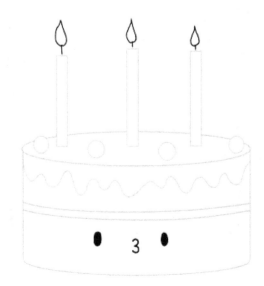

1

2

3

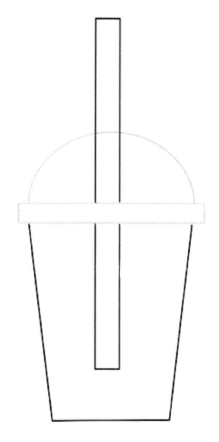

4

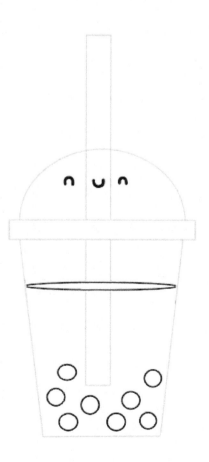

1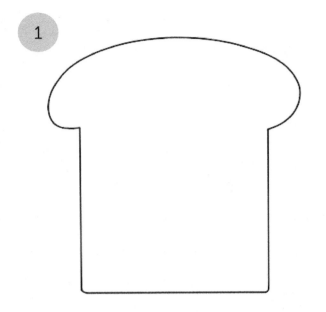

2

3

4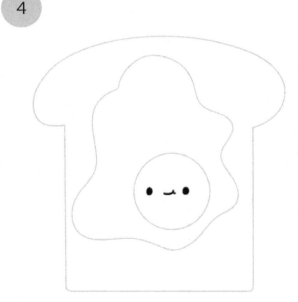

Bread and Egg

Happy Foods

1

2

3

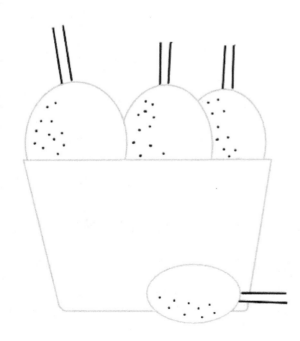

4

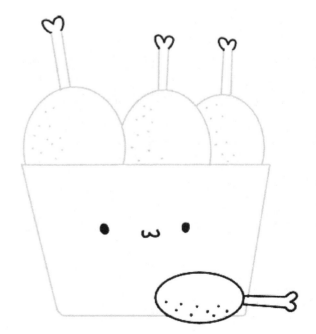

1

2

3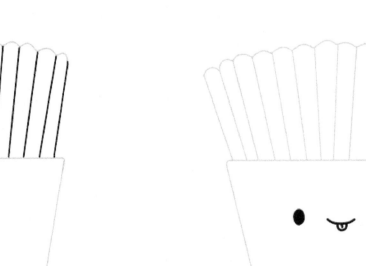

4

1

2

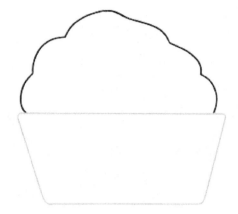

3

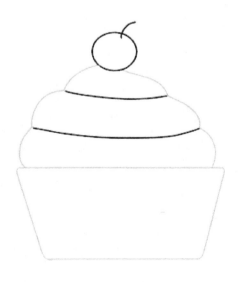

4

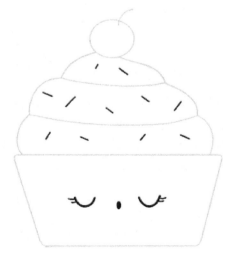

Donut

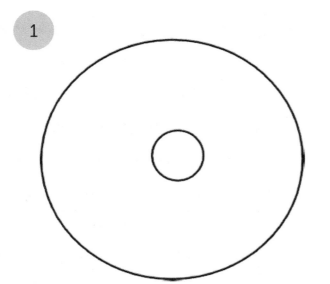

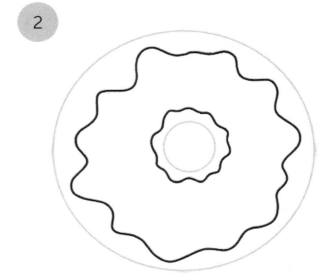

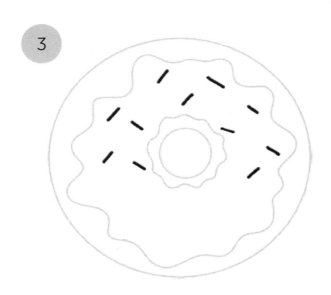

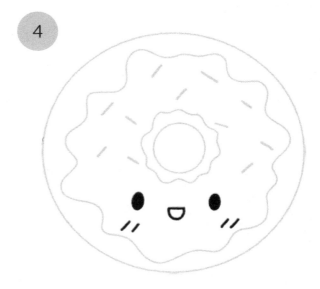

 1

2

3

4

5

6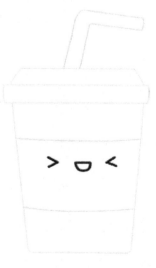

Happy Foods

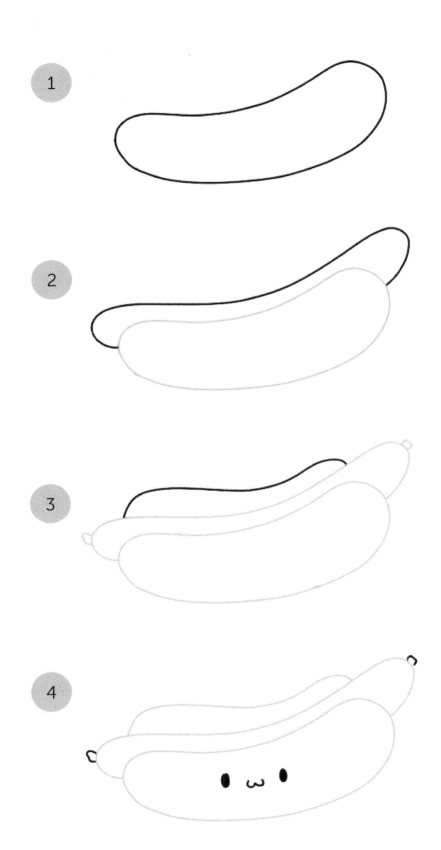

Happy Foods

1

2

3

4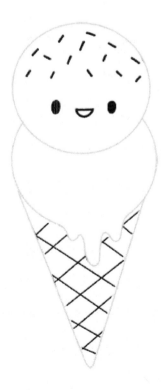

Popsicle

1

2

3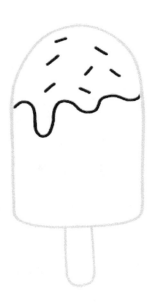

4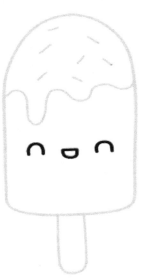

Happy Foods

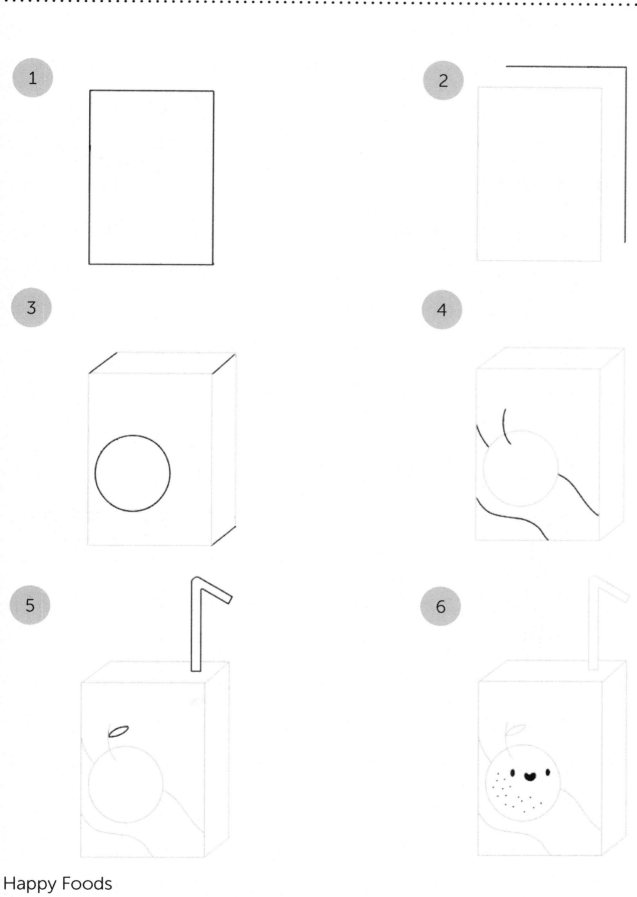

Happy Foods

 Noodles

1

2

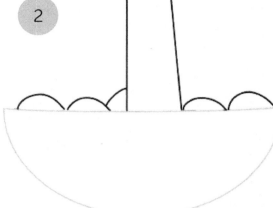

3

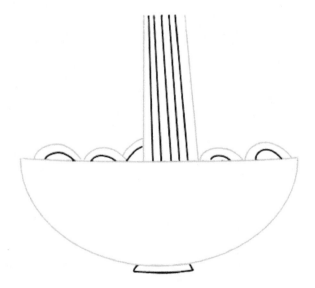

4

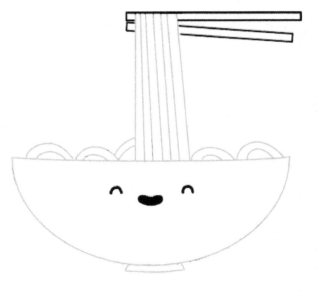

1

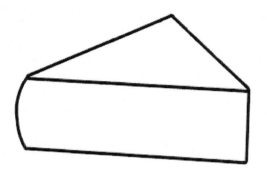

2

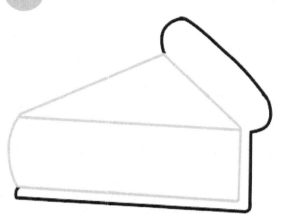

3

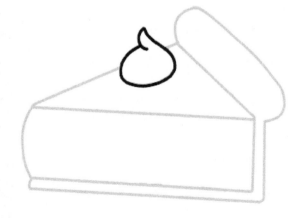

4

1

2

3

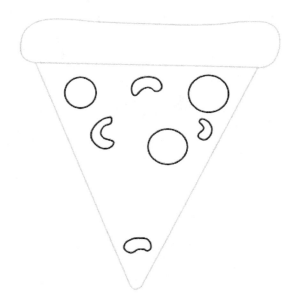

4

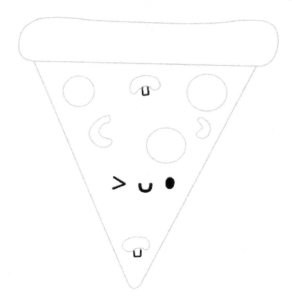

Happy Foods

1

2

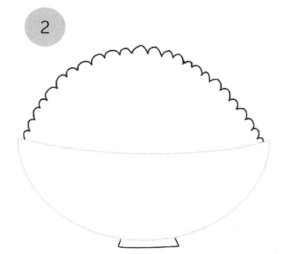

3

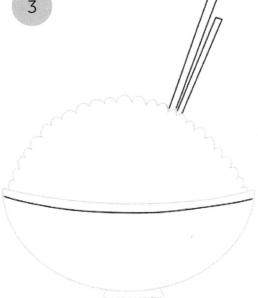

4

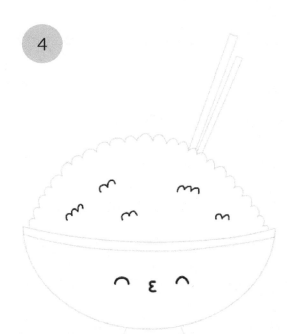

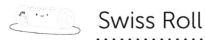

1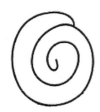

2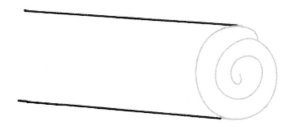

3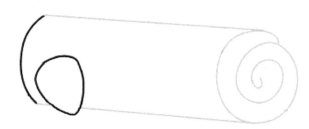

4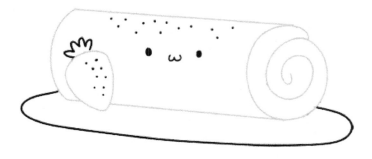

1

2

3

4

1

2

3

4

DRAWING THEMES
Mythical Creatures

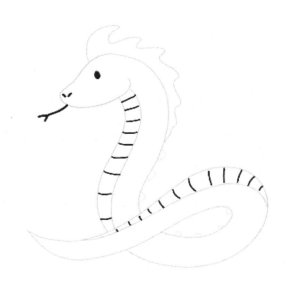

Basilisk

1

2

3

4

5

6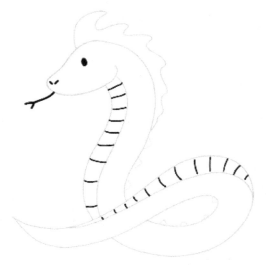

Mythical Creatures

1

2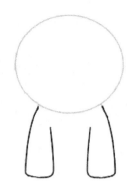

3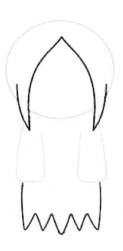

4

5

6

Mythical Creatures

Boogeyman

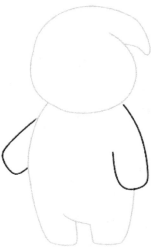

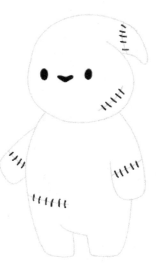

Mythical Creature

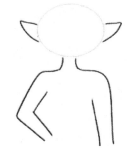

1

2

3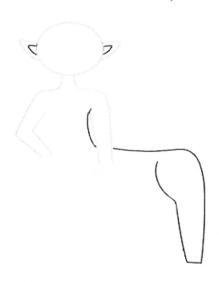

4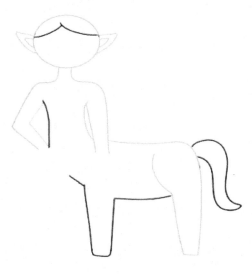

5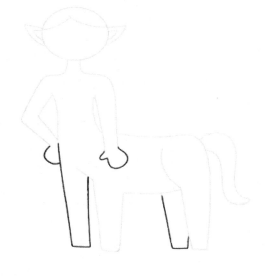

6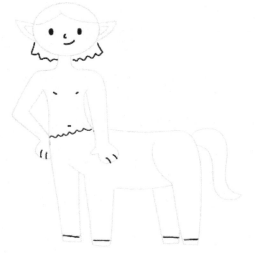

1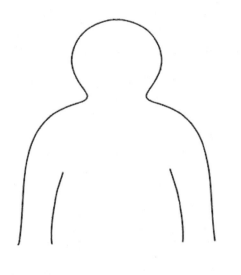

2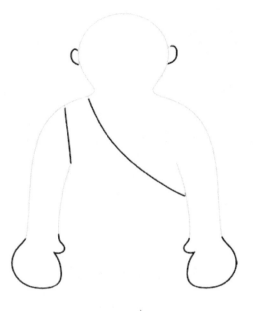

3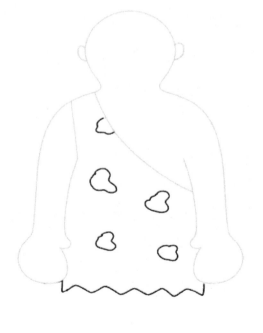

4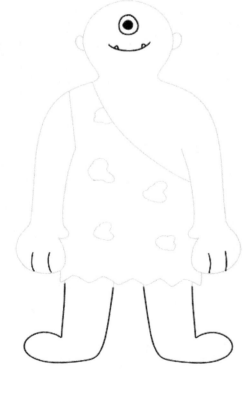

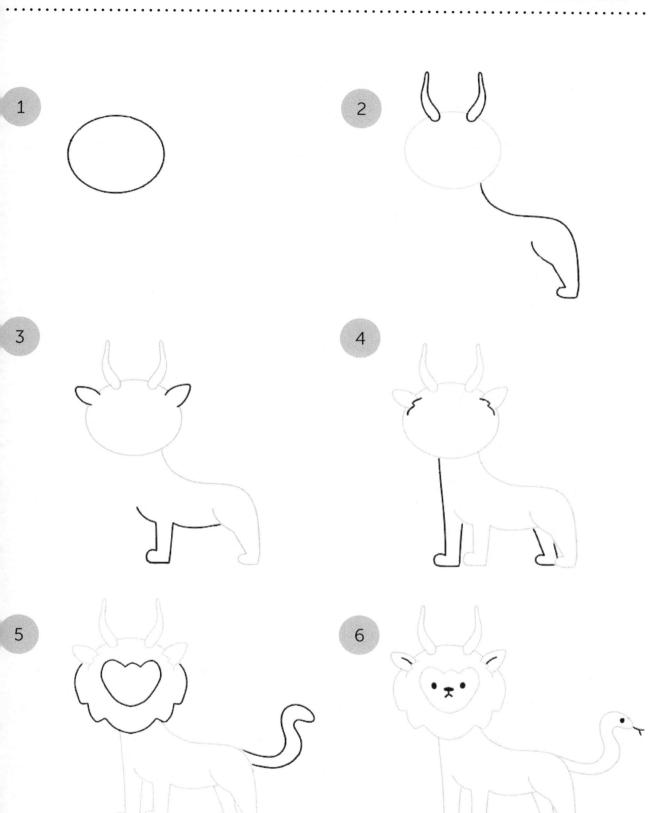

Dragon

1

2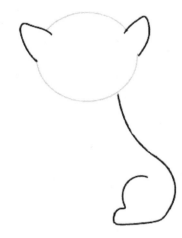

3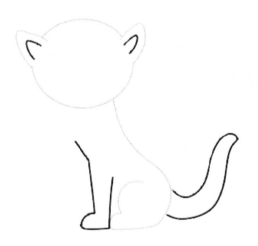

4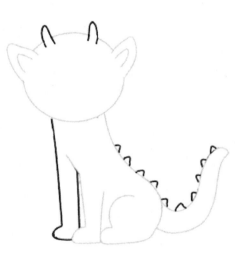

5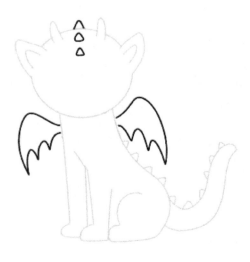

6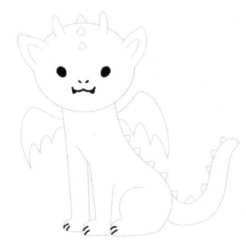

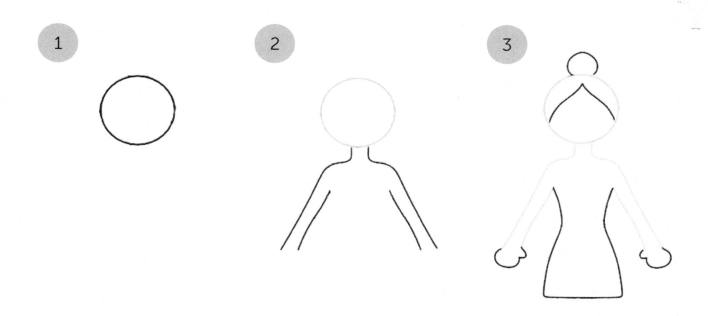

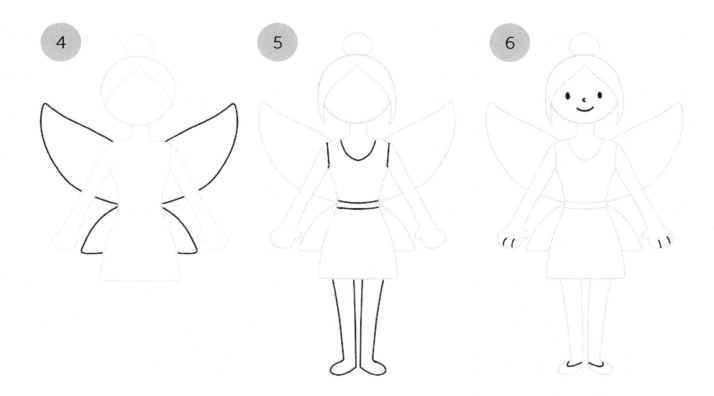

Golem

1

2

3

4
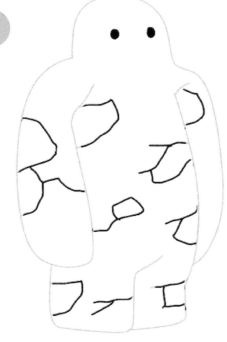

54

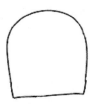

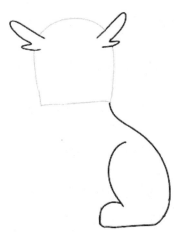

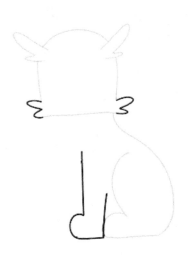

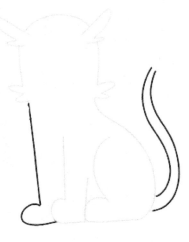

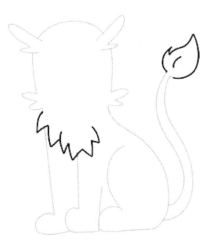

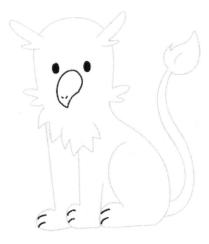

1

2

3

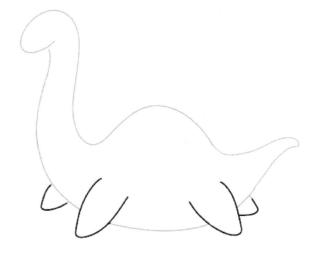

4

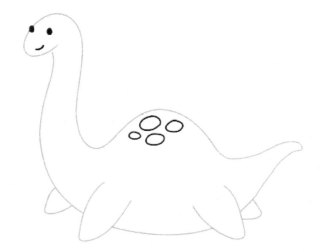

Mythical Creature

1

2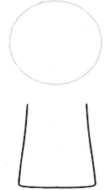

3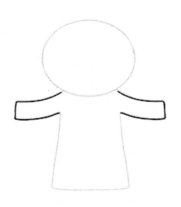

4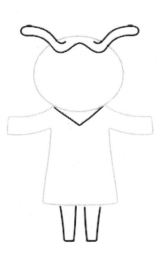

5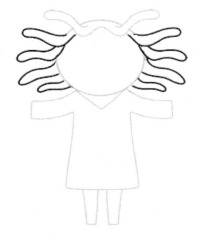

6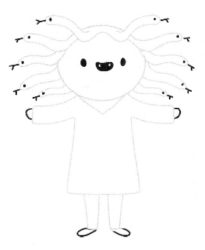

1

2

3

4

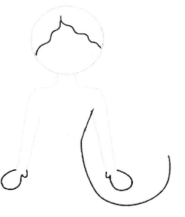

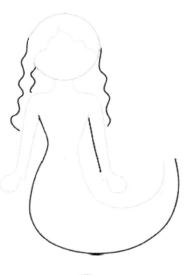

5

6

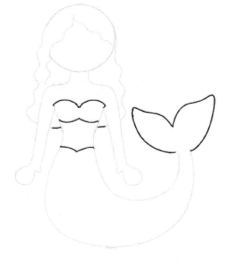

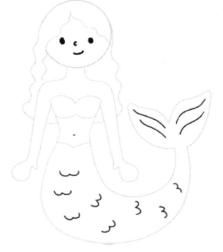

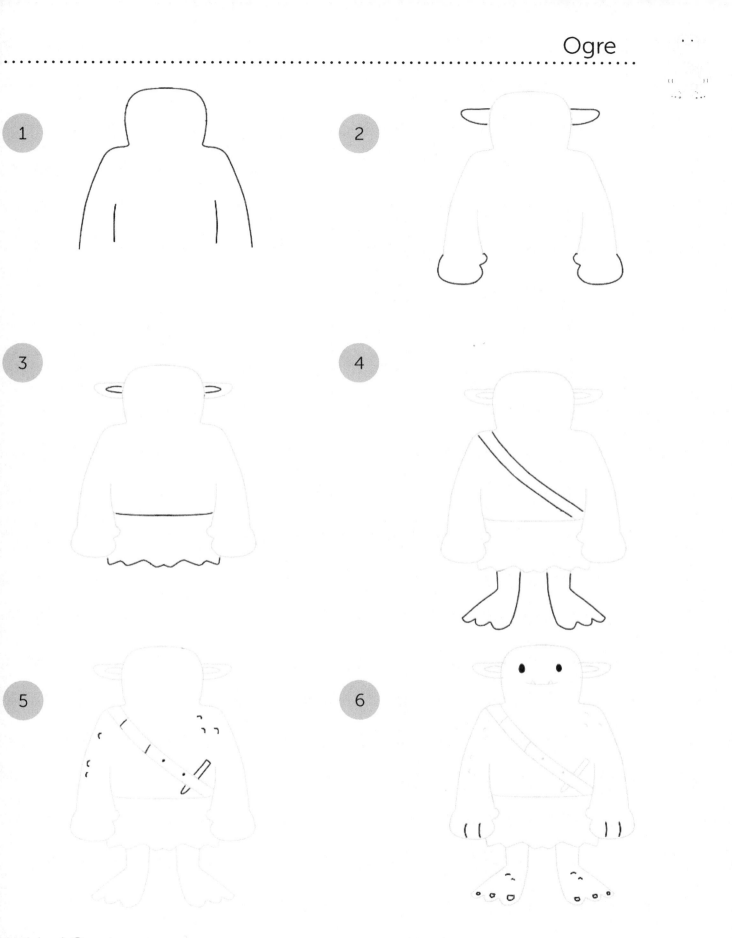

Phoenix

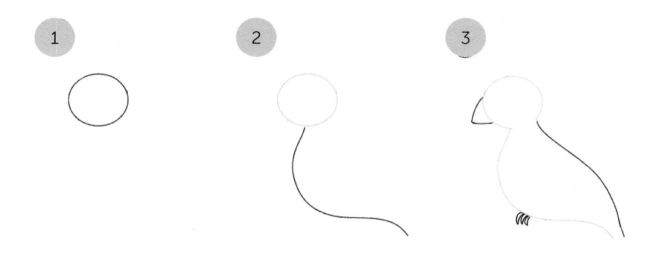

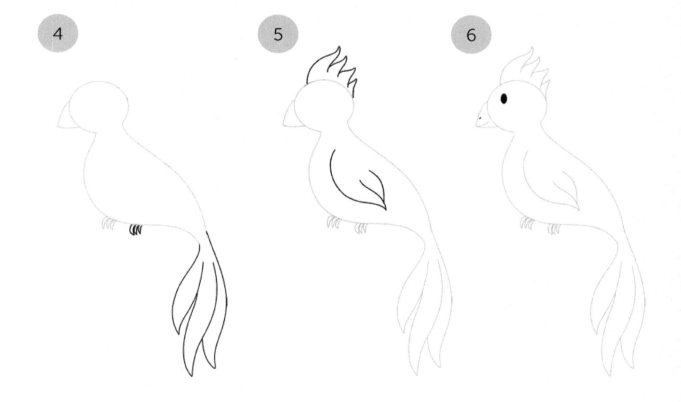

Mythical Creature

1

2

3

4

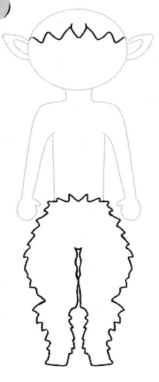

5

6

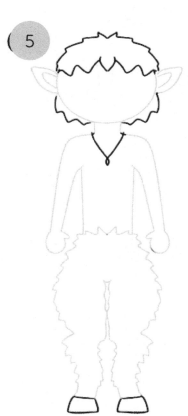

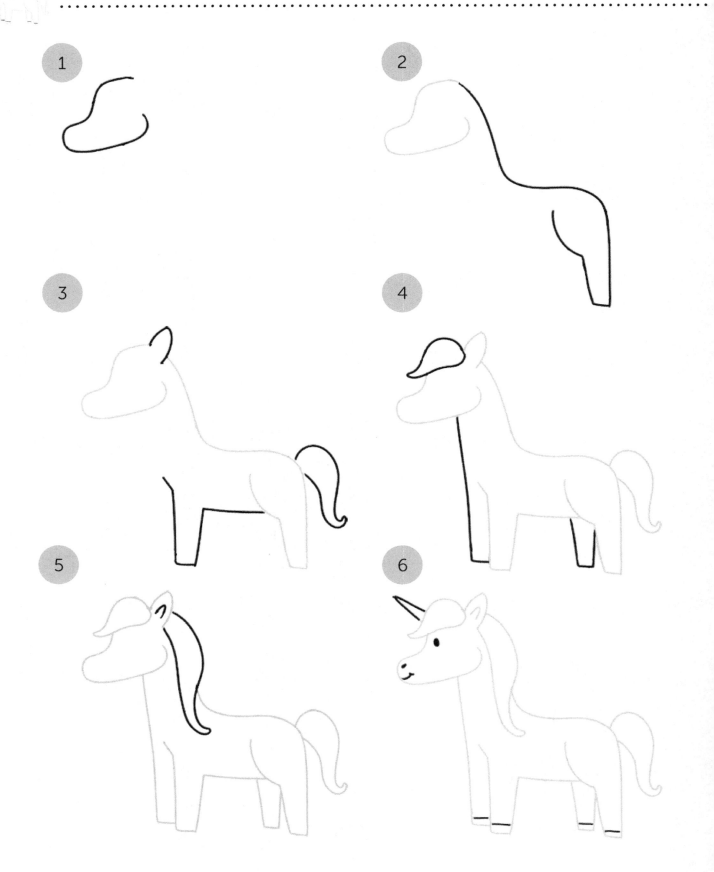

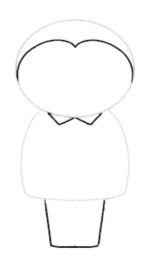

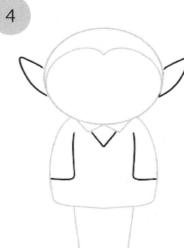

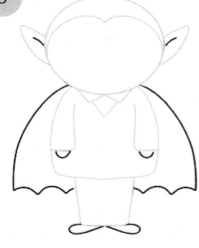

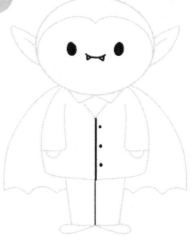

Yeti

1

2
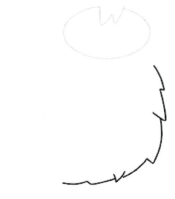

3
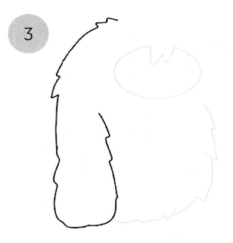

4
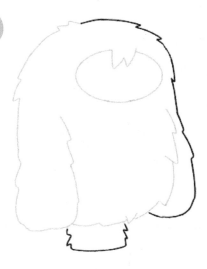

5
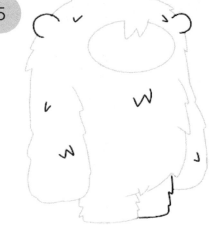

6
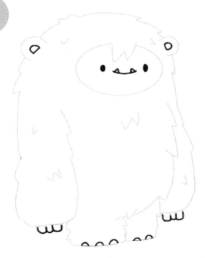

Mythical Creature

1

2

3

4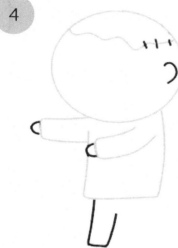

5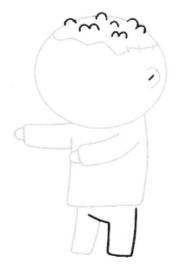

6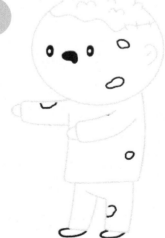

DRAWING THEMES
Things that Go!

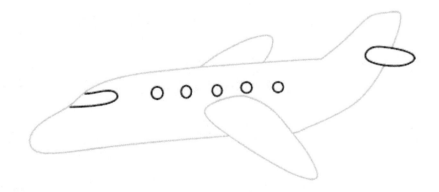

1

2

3

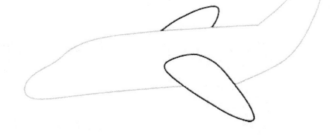

4

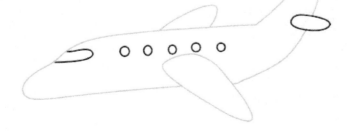

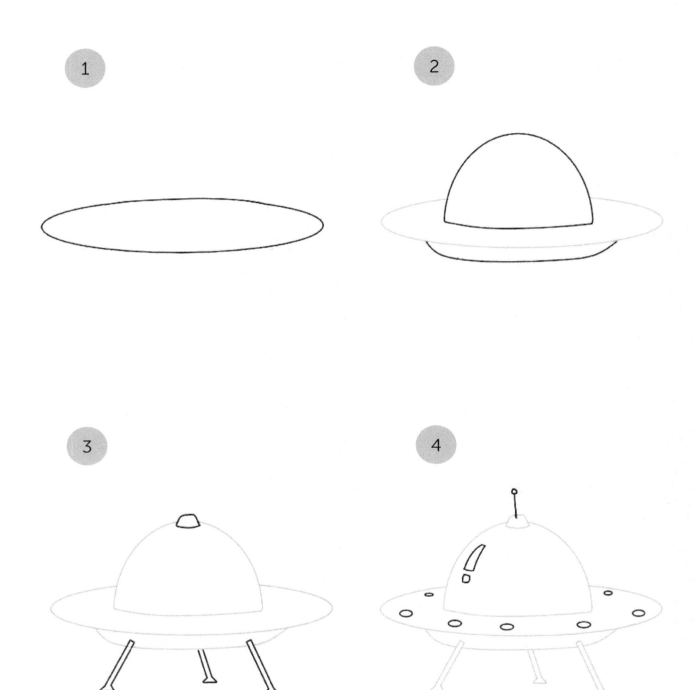

Air Balloon

1

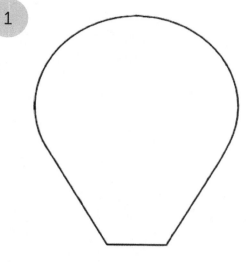

2

3

4

1

2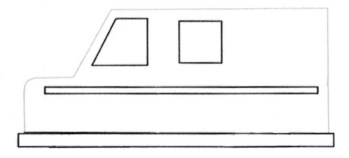

3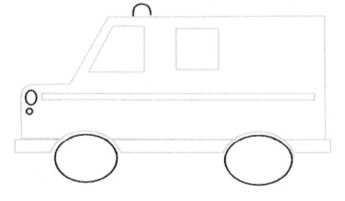

4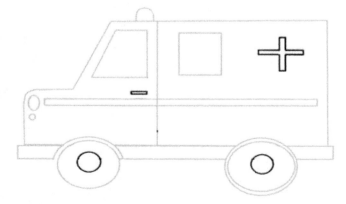

Things that Go!

1

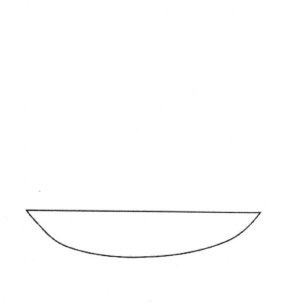

2

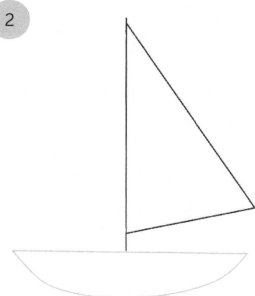

3

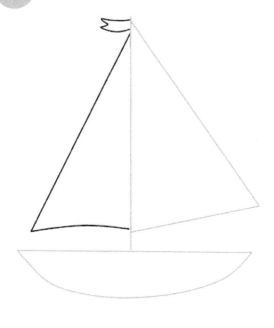

4

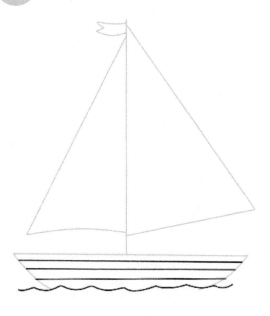

Things that Go!

1

2

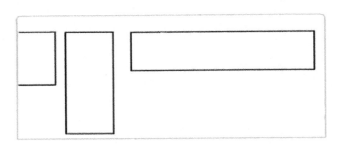

3

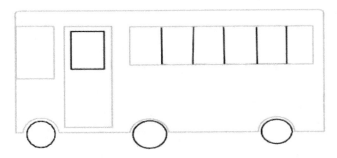

4

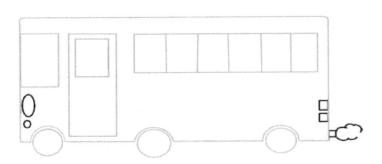

Things that Go!

1

2

3

4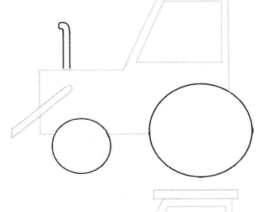

Things that Go!

1

2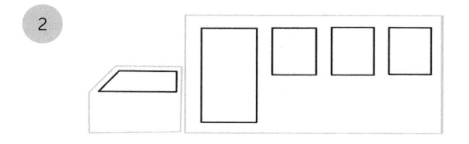

3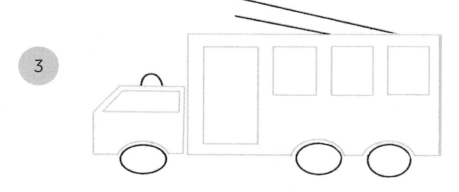

4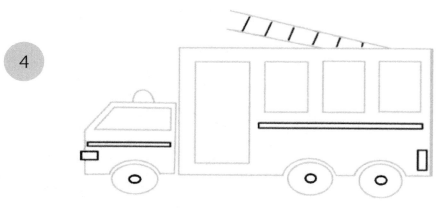

Things that Go!

1

2

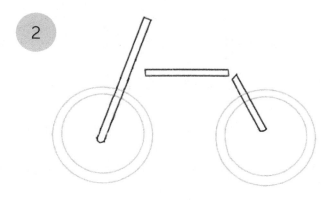

3

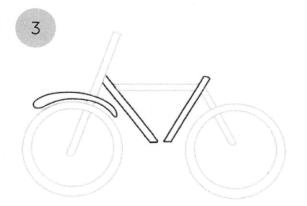

4

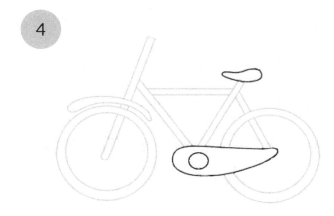

5

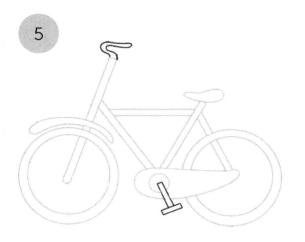

6

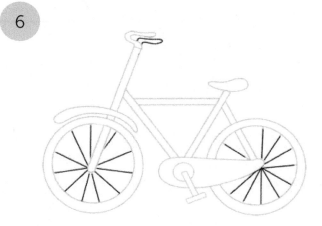

Things that Go!

1

2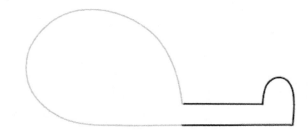

3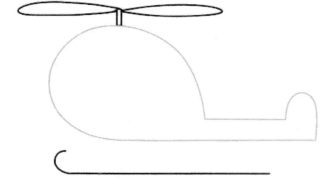

4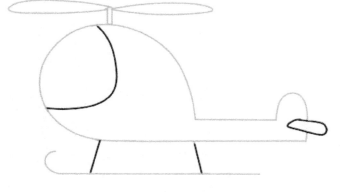

Police car

1

2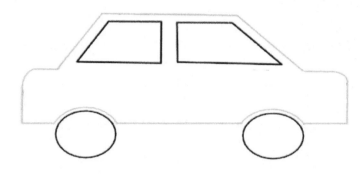

3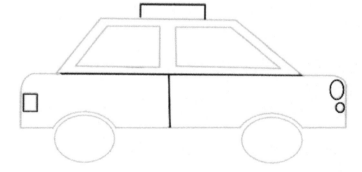

4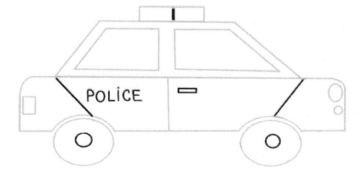

Things that Go!

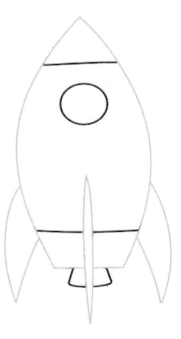

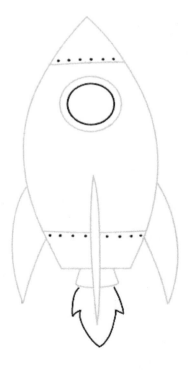

Things that Go!

1

2

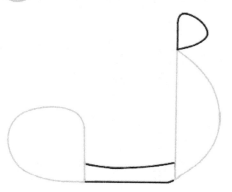

3

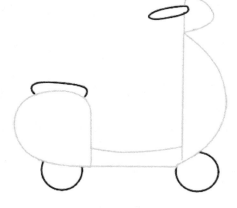

4

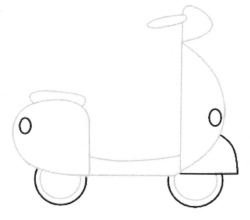

Things that Go!

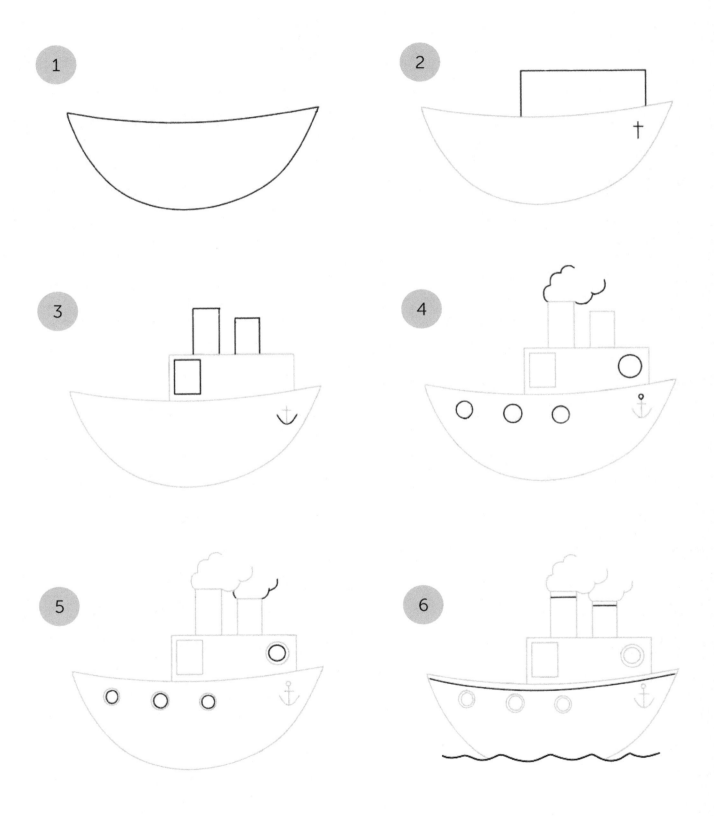

1

2

3

4

5

6

Things that Go!

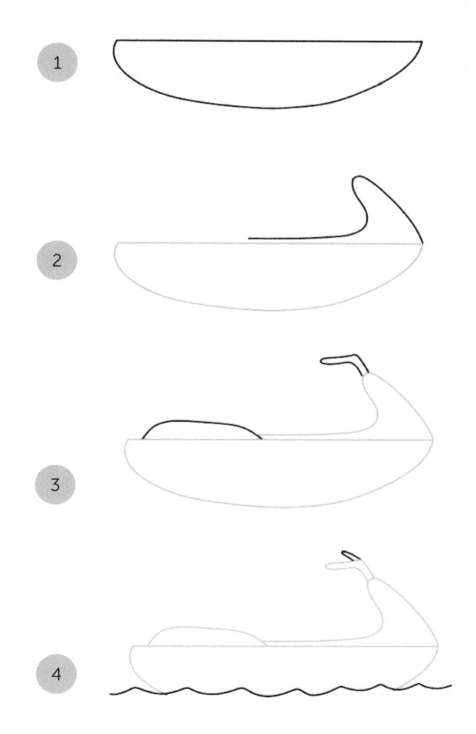

1

2

3

4

1

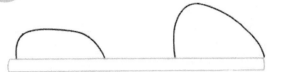

2

3

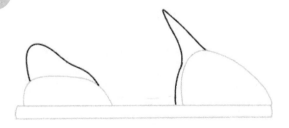

4

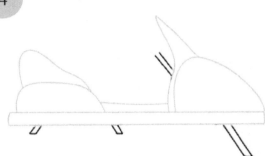

5

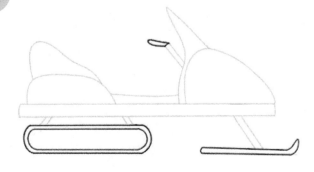

6

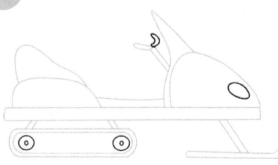

1

2

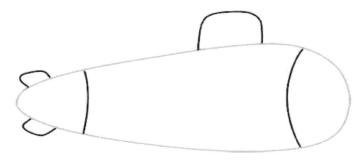

3

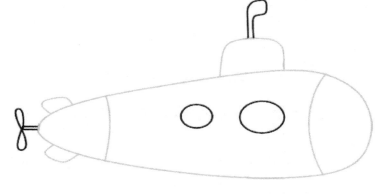

4

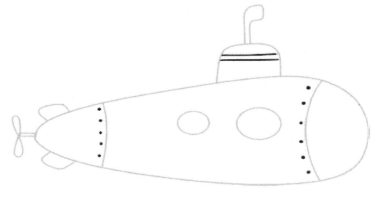

1

2

3

4

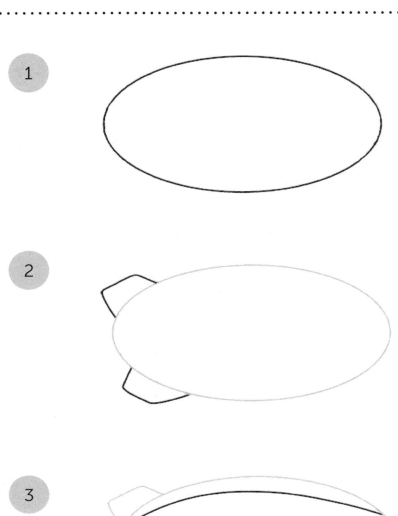
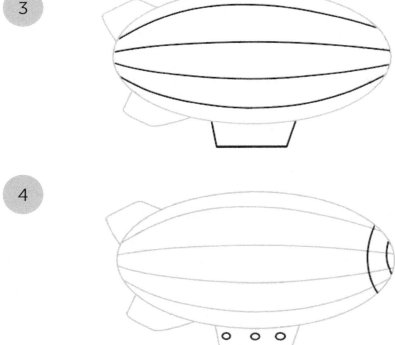

Things that Go!

1

2

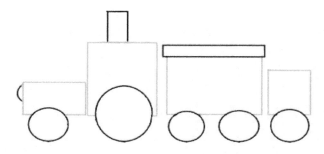

3

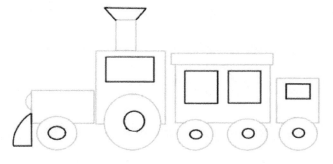

4

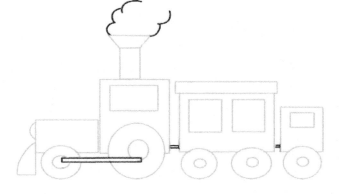

1

2

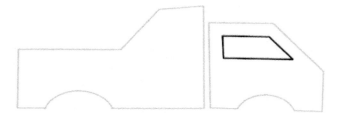

3

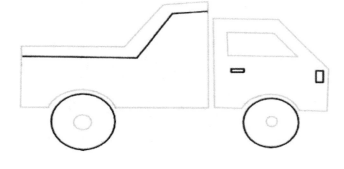

4

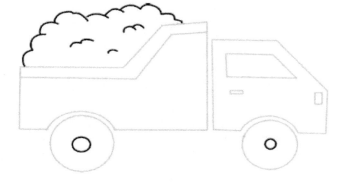

Things that Go!

DRAWING THEMES
Random Fun

1

2

3

4

 Happy Cactus

1

2

3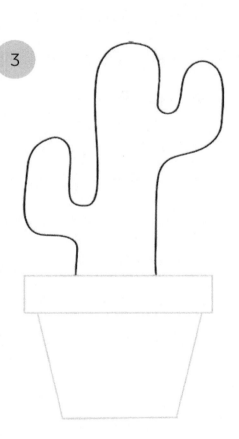

4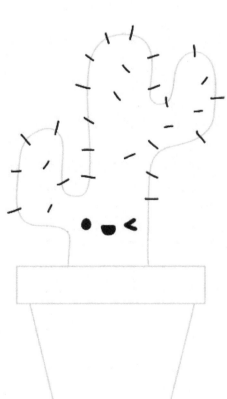

Random Fun

1

2

3

4

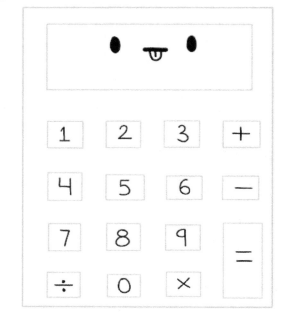

Random Fun

1

2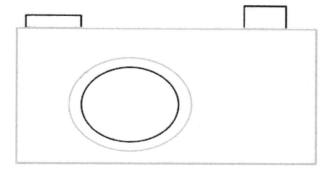

3

4

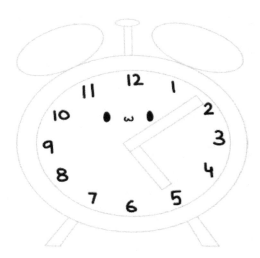

Random Fun

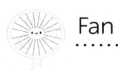 Fan

..

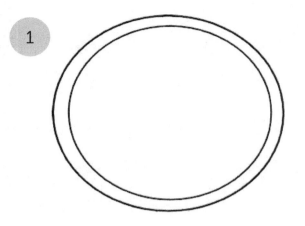

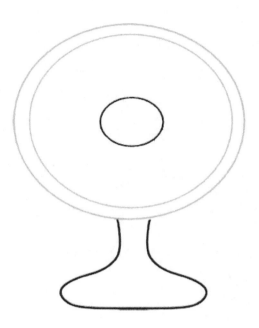

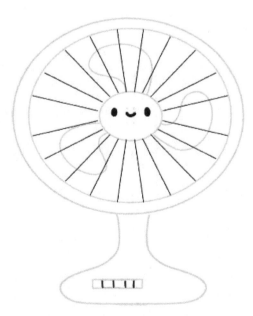

Random Fun
..

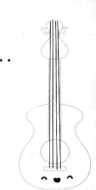

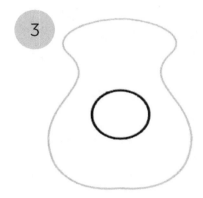

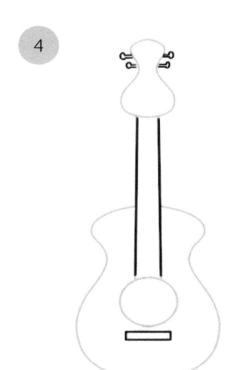

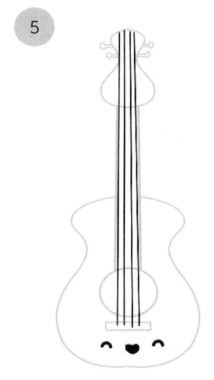

Kettle

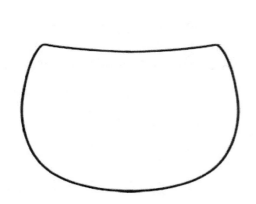

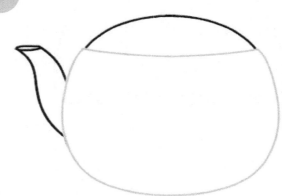

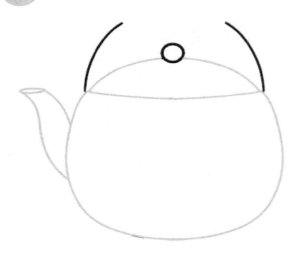

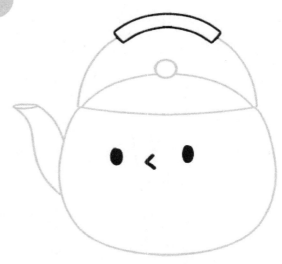

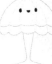

1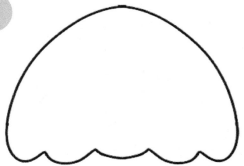

2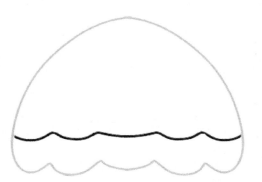

3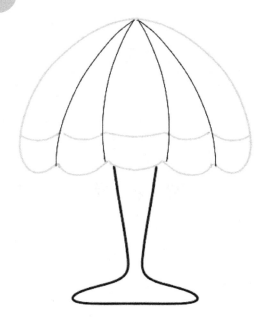

4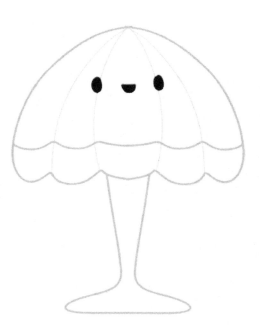

Pen

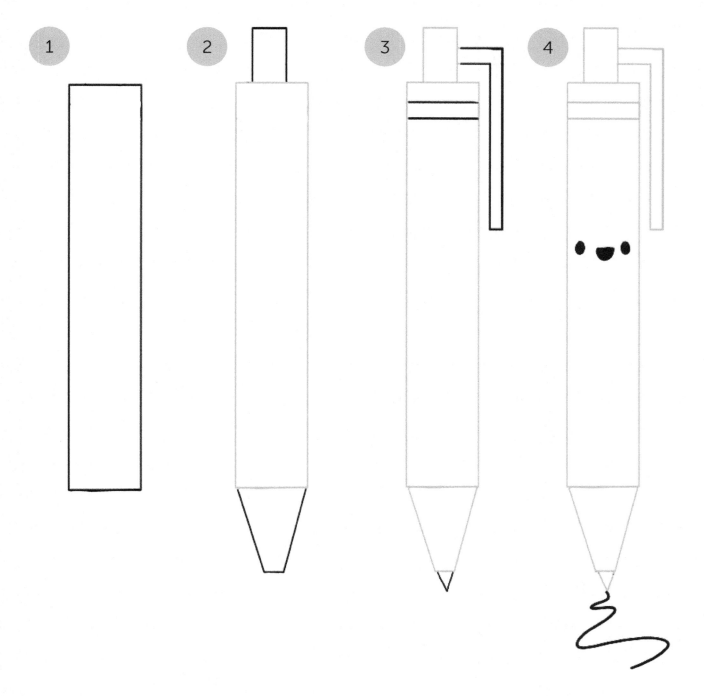

Random Fun

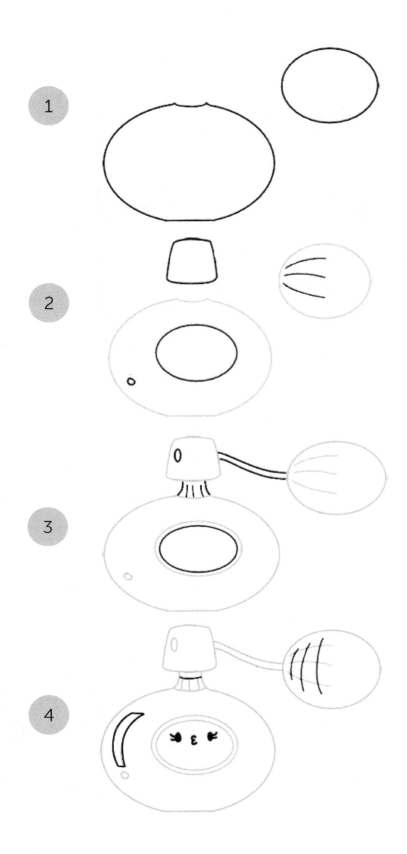

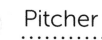
1

2

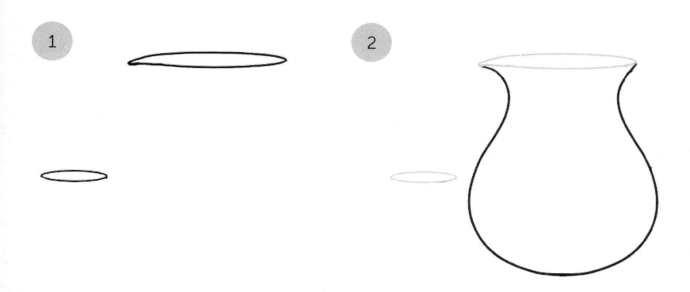

3

4

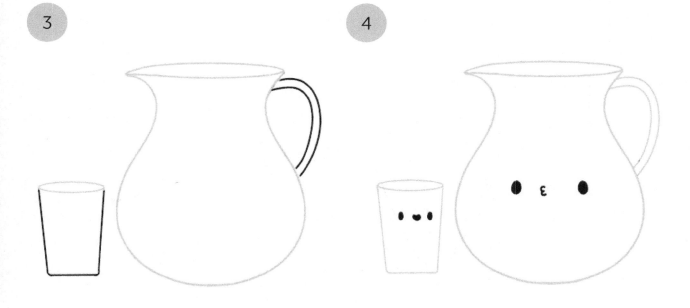

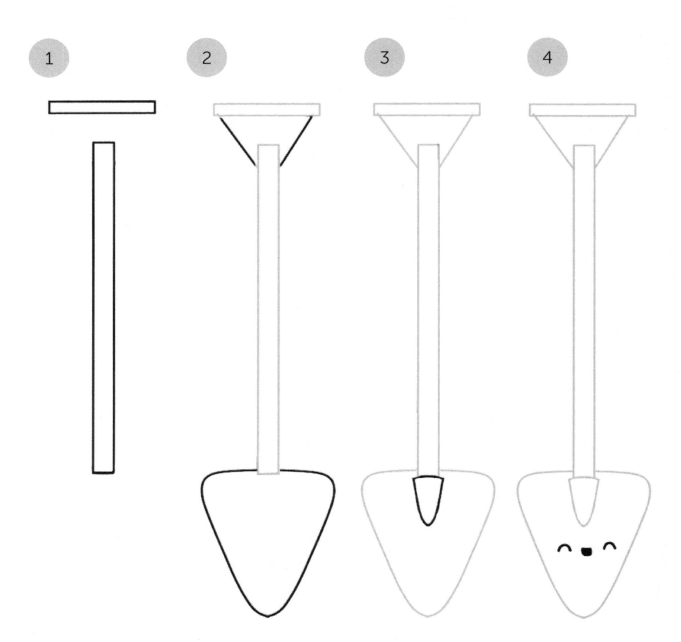

 Soap

1

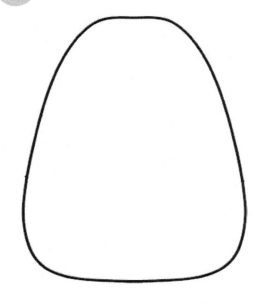

2

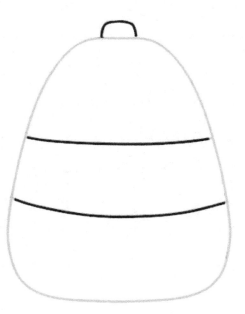

3

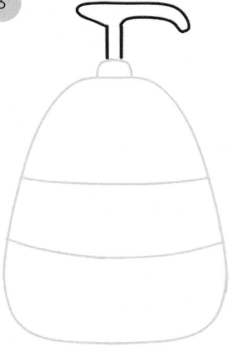

4

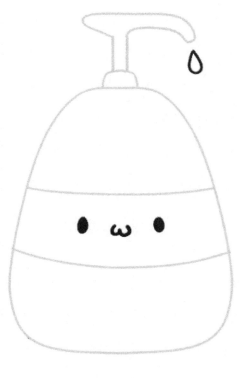

1
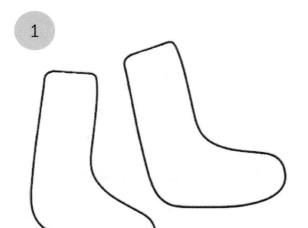

2
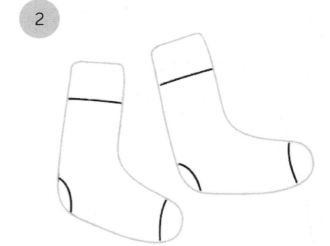

3
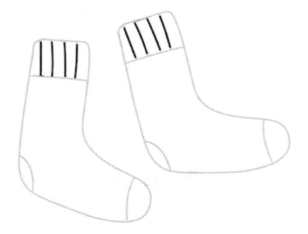

4
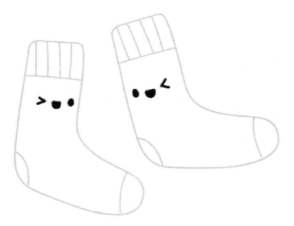

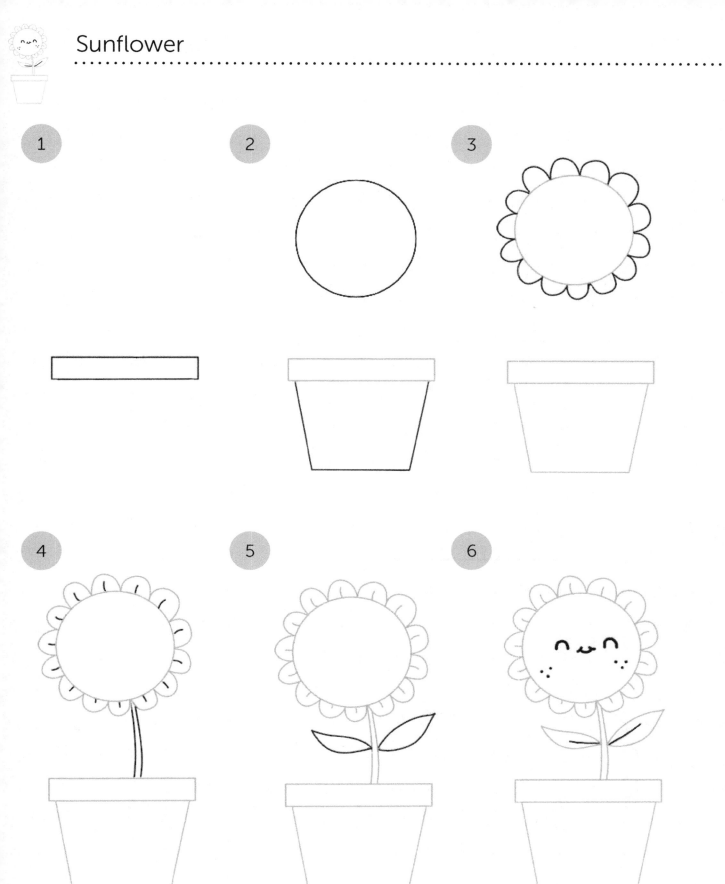

1

2

3

4

5

6

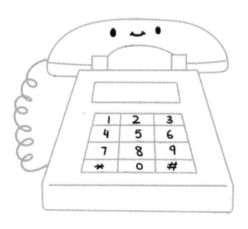

1

2

3

4

1

2

3

4

5

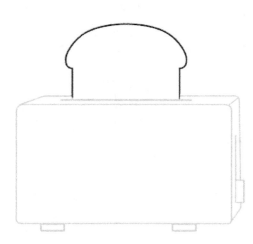

6

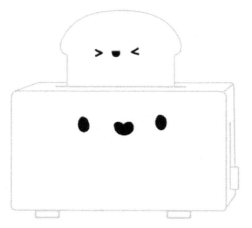

Umbrella

1

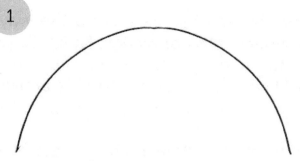

2

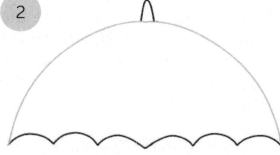

3

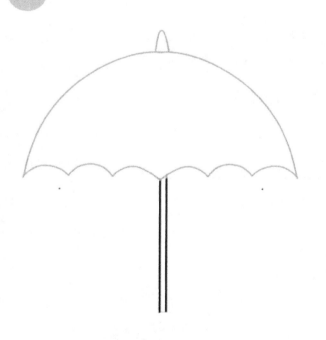

4

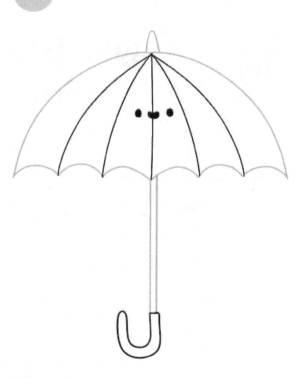

CONGRATULATIONS!

You're truly amazing! I am sure there were some obstacles along the way; it was great that you persisted through and finished the drawings! Fantastic job! If you want to continue with some more fun activities, just send me an email to support@kidsactivitybooks.org and I will send you some printable activities for free.

My name is Jennifer Trace and I hope you found this drawing book helpful and fun. If you have any suggestions about how to improve this book, changes to make or how to make it more useful, please let me know.

If you like this book, would you be so kind and leave me a review on Amazon.

Thank you very much!

Jennifer Trace

Congratulations
Drawing Star:

THE BEST!

Date:_____ **Signed:_____**

Made in the USA
Las Vegas, NV
10 March 2021